andy Warhol Drawings

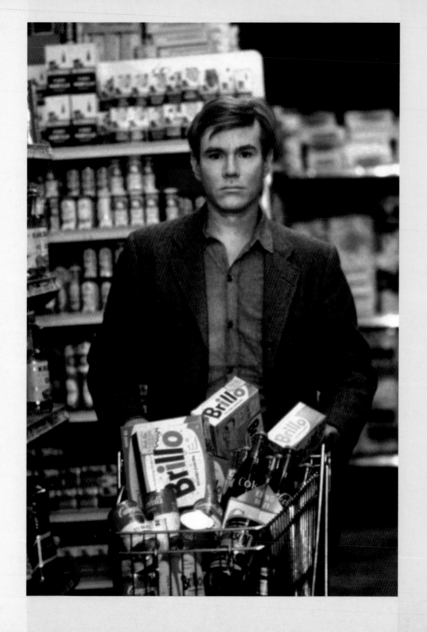

andy Warhol

Drawings

CHRONICLE BOOKS
SAN FRANCISCO

First published in the United States in 2012 by Chronicle Books.

Copyright © 2007 by Éditions Palette.
Pages 78–79 constitute a continuation of the copyright page.
All rights reserved. No part of this book may be reproduced in any
form without written permission from the publisher.

Library of Congress Cataloging-in-Publication Data available.

ISBN: 978-1-4521-1203-9

Manufactured in Singapore.

Type redesign: Anne Kenady and Brooke Johnson
Graphic design and layout of the original edition: Raphaël Hadid
With the participation of: Aglaë de La Genardière

10 9 8 7 6 5 4 3 2 1

Chronicle Books LLC
680 Second Street
San Francisco, CA 94107

www.chroniclebooks.com

In the future everybody will be world famous for fifteen minutes.

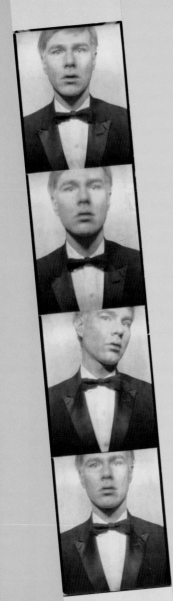

PREFACE

Andy Warhol is a legend. The son of poor immigrants, fascinated with America, he rose by means of his considerable cheek and intelligence to become an icon of contemporary art. His portraits of celebrities, his reproductions of Campbells soup cans, of Brillo boxes, have traveled all over the world. He created a fascinating and fascinated portrait of 20th-century America and developed an instantly recognizable body of work; he exerted, and continues to exert, an immense influence on numerous aspects of contemporary art. His fame also owes much to his personality and carefully cultivated reputation. He was widely considered a phony, a pseudo-artist who actually did nothing more than reproduce, barely modified, images that already existed. And yet...even in his most impersonal works, even when he had them executed by others, even though he declared his desire to disappear behind his productions, we can always identify the Andy Warhol style, his "touch," his art . . .

With this book we discover a little-known area of Warhol's oeuvre: his drawings. And a thrilling discovery it is. First because most of these drawings are among his earliest works, giving us a glimpse into the genesis of a myth. But also because they tell us a lot about Andy Warhol, his imagination, his work method, his style. . . . Discovering Andy Warhol's drawings, we discover his intimate self.

AN ADVERTISING ARTIST AND AN ADVERTISER FOR ART

When he finished his studies, Warhol set out for New York with a thick portfolio of drawings under his arm. For him, New York was a sort of Platonic ideal, the sole locus of success, the city where everything was possible. There he met the art director of *Glamour:* the magazine title alone, synonymous with elegance, magic, and beauty, drew him like a magnet. Soon he was asked to imagine "ideal" shoe styles. Warhol showed up the next day with 50 drawings. They were veritable princess shoes, each more glamorous than the last. . . . In a few years, Andy Warhol became one of the best-known and highest-paid designer-illustrators in New York. He worked for the top fashion magazines; his creations were featured on album covers, book covers, posters, postcards. . . . The man who had produced ads that were almost art, ended up making art that was almost ads.

Most of the drawings seen here are commissioned works. One might think this a far cry from art, "pure" art, unconstrained, in which the artist expresses a deeply personal, individual vision. Paradoxically, however, it is in these commissioned works that Warhol finds his style and manifests his imagination. Under these constraints, he felt free. He adored projects in which the client could say yes or no, or might demand changes. He enjoyed the feeling that he was merely executing a task.

"I was getting paid for it, and I did anything they told me to do. If they told me to draw a shoe, I'd do it, and if they told me to correct it, I would, I'd do anything they told me to do, correct it and do it right. I'd have to invent and now I don't; after all that 'correction,' those commercial drawings would have feelings, they would have a style. [. . .] The process of doing work in commercial art was machine-like, but the attitude had feeling to it."

—Andy Warhol
Interviews with G. R. Swenson, 1963

Feeling, style. . . . Warhol cites these when speaking of his most impersonal products, though he would have rejected these terms in reference to his "oeuvre." But style and feeling are definitely present. Style first: a pencil drawing retraced in ink and then, before it dries, blotted with a sheet of paper. This was the way Warhol created that wavering, imperfect, "drippy" line in his blotted line drawings, which appeared spontaneous, fragile, almost awkward . . . in short, the inimitable style for which he would come to be known ever after.

And feeling. These drawings display an imagination that was his alone: celebrities' shoes, childhood, fashion, show business, feminine imagery, "chic" . . . It is all there from the start, even the taste for the over-the-top,

for cliché, for sequins and paste. Without perhaps meaning to, Warhol shows us something quite intimate here, a few keys to his future art. He who declared his wish to become an art-making machine reveals just the opposite. Style is not important, Warhol proclaimed. Nonetheless, we know quite well and it jumps out at us in these drawings marked by mastery and clumsiness at once that style makes the man. . . .

Christian Demilly

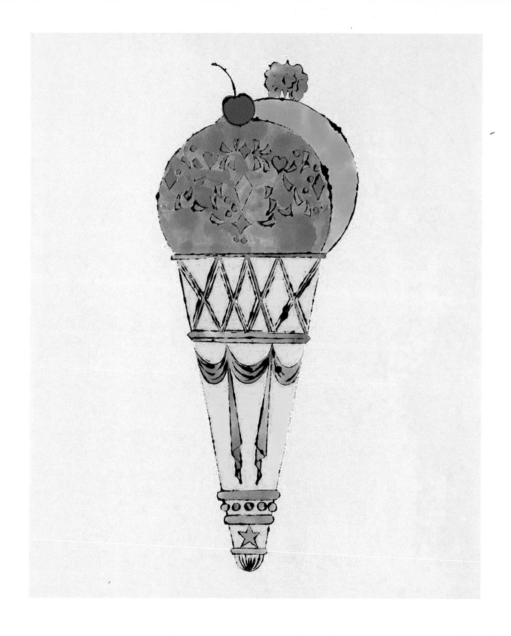

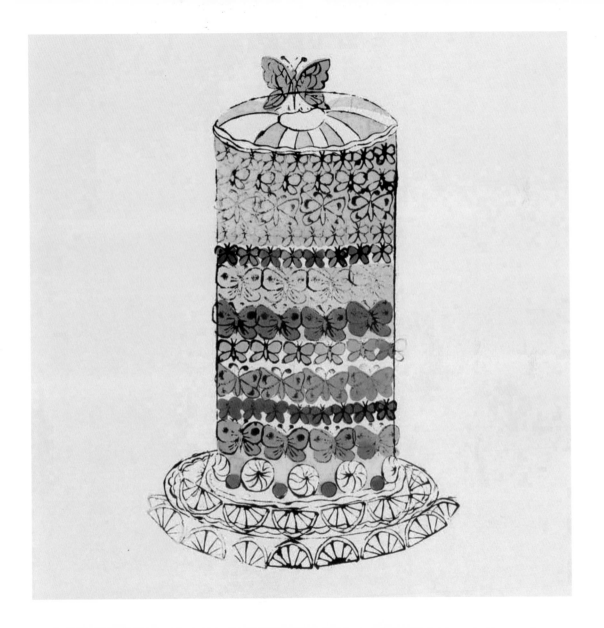

13

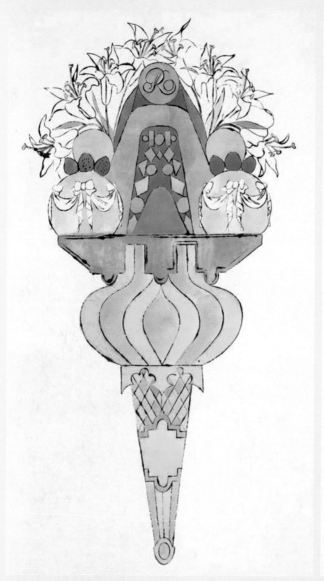
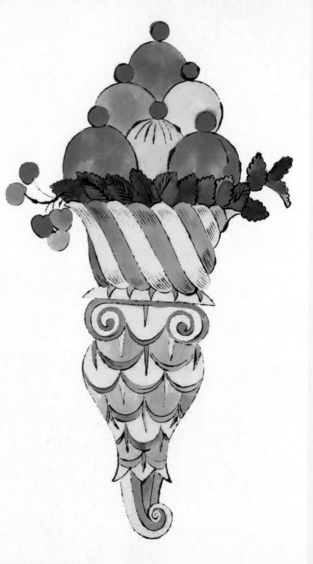

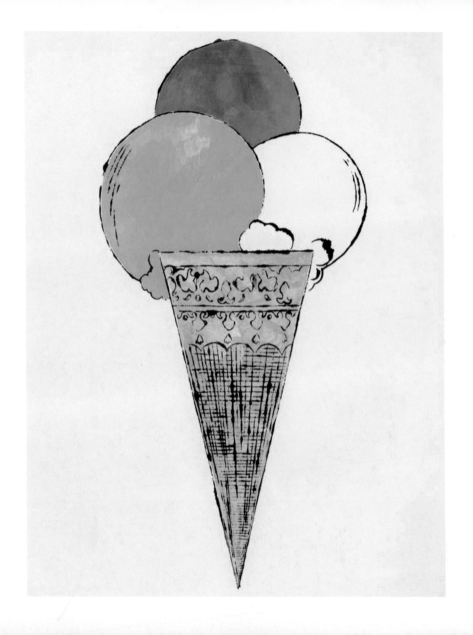

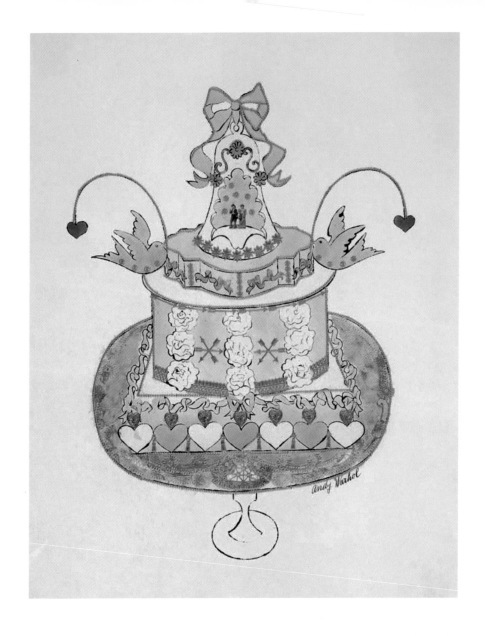

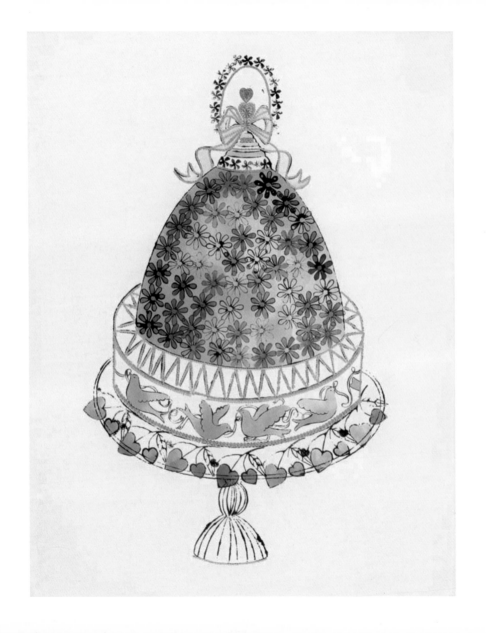

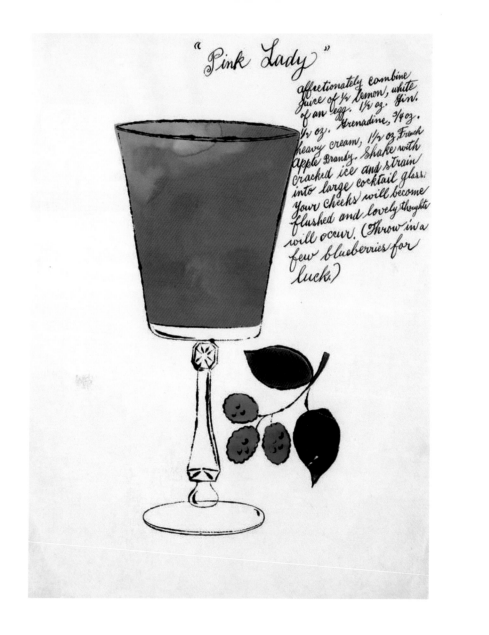

"Pink Lady"

affectionately combine juice of ½ lemon, white of an egg, 1½ oz. Gin, ½ oz. Grenadine, ¾ oz. heavy cream, 1½ oz. French apple Brandy. Shake with cracked ice and strain into large cocktail glass. Your cheeks will become flushed and lovely thoughts will occur. (Throw in a few blueberries for luck.)

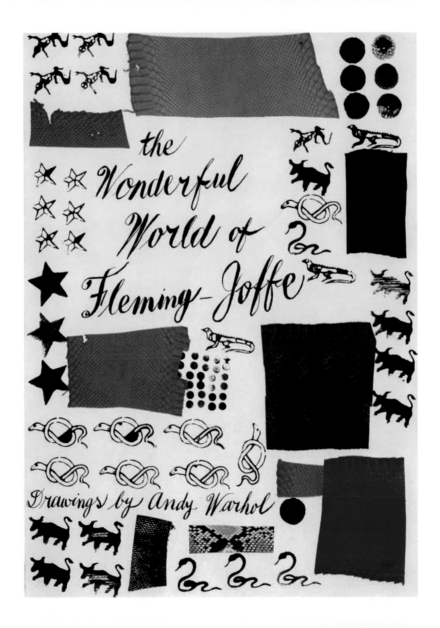

the
Wonderful
World of
Fleming-Joffe

Drawings by Andy Warhol

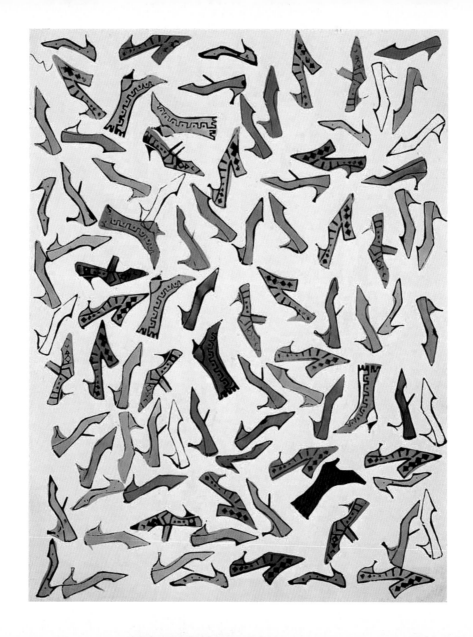

Recently, someone commissioned me to do a painting of shoes.

I liked it so I started doing more of them.

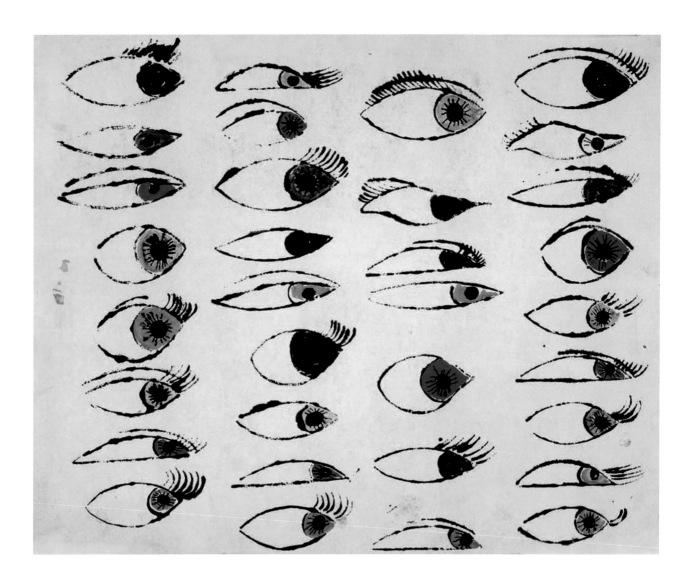

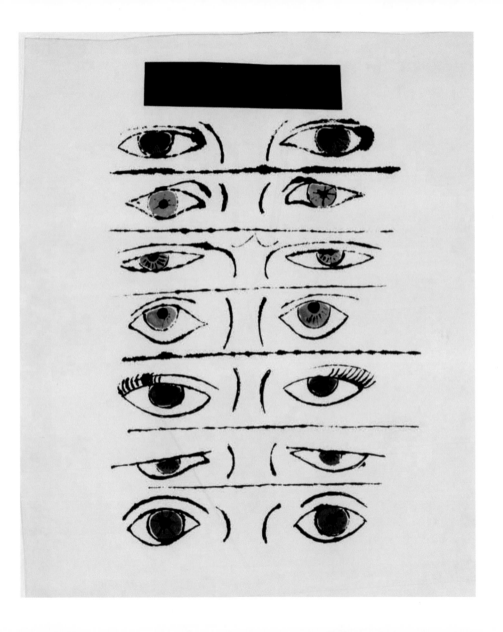

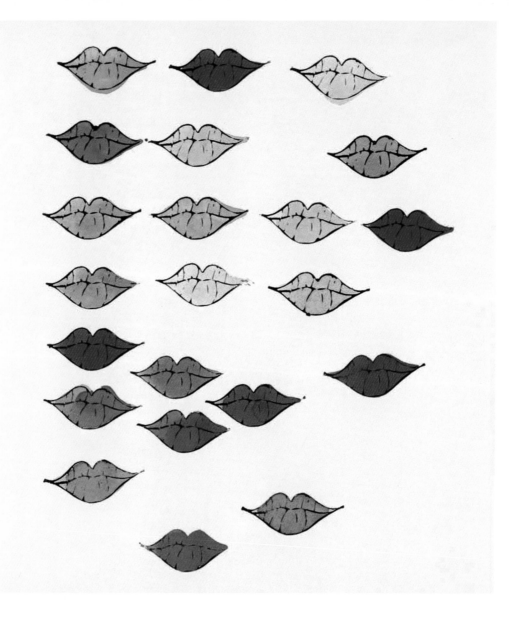

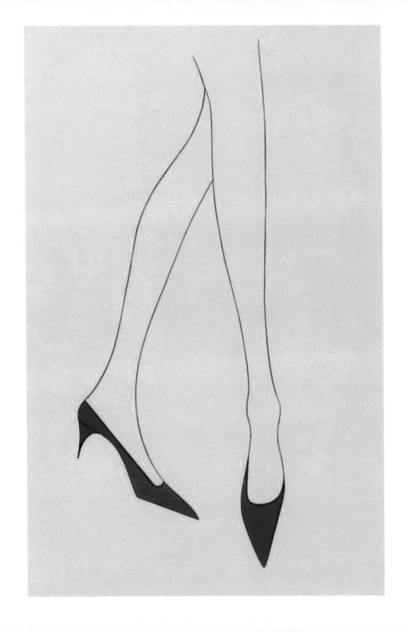

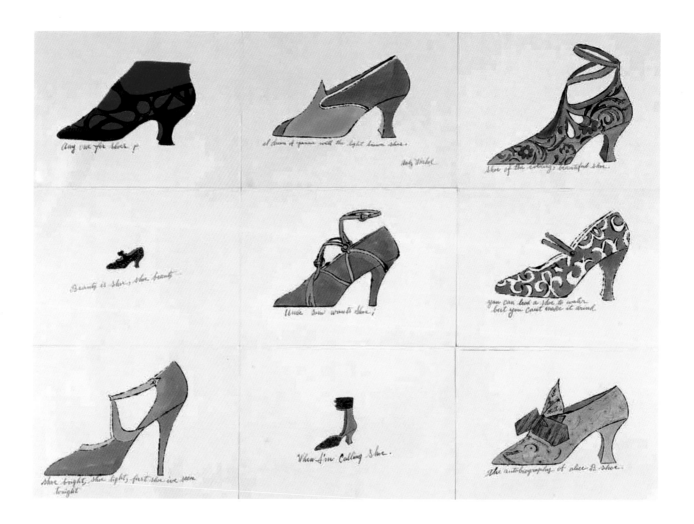

Any one for shoe?

a dream of genius with the light brown shoe.

Andy Warhol

shoe of the evening, beautiful shoe.

Beauty is shoe, shoe beauty.

Uncle Sam wants Shoe!

you can lead a shoe to water but you can't make it drink.

shoe bright, shoe lights, first shoe ive seen tonight

When I'm Calling Shoe.

the autobiography of alice B. shoe.

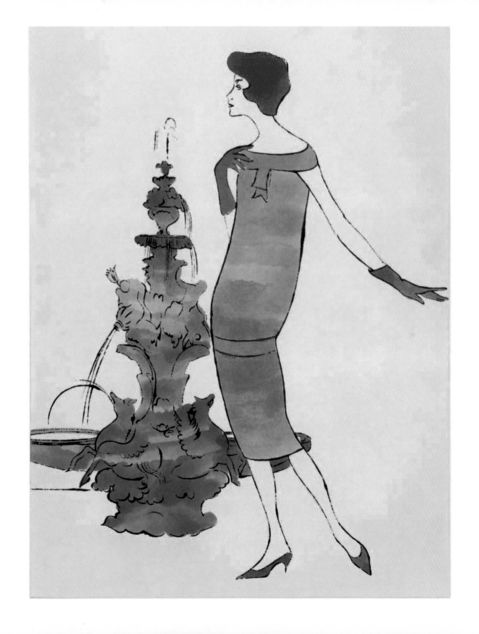

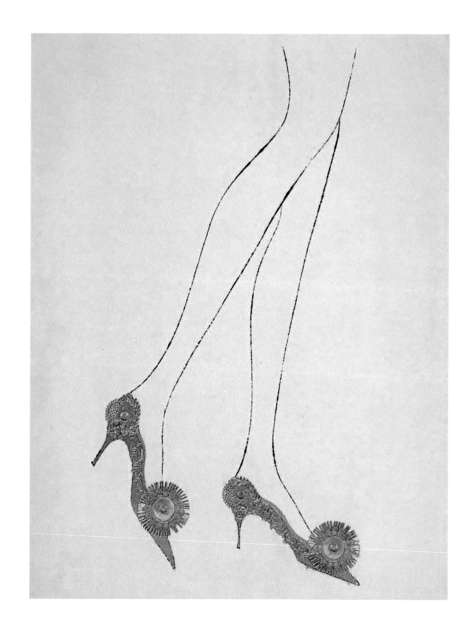

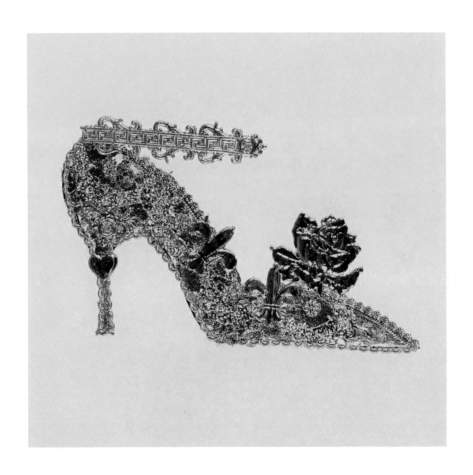

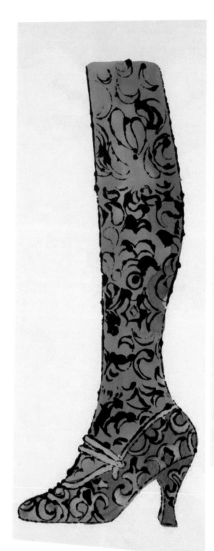
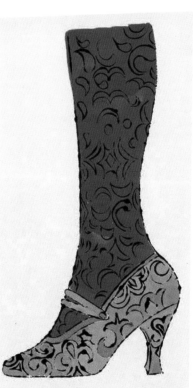
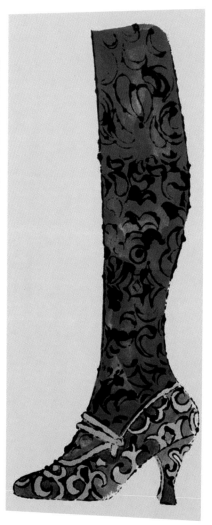

I think American women are all so beautiful, I like the way they look, **they're terrific.**

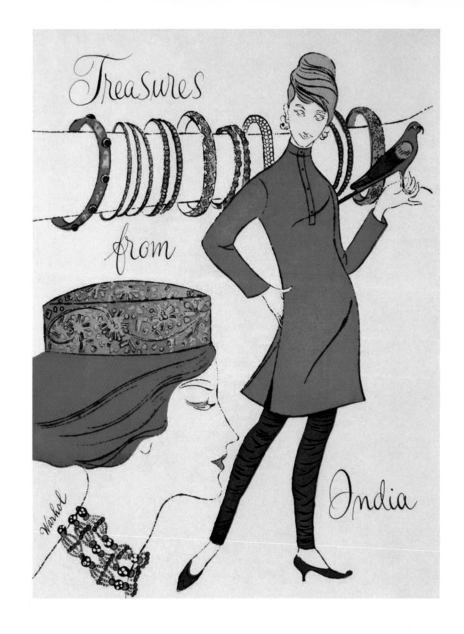

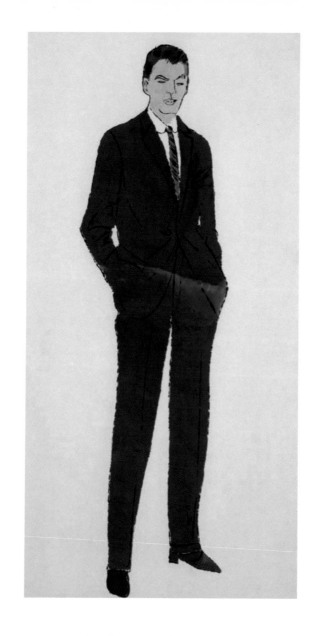

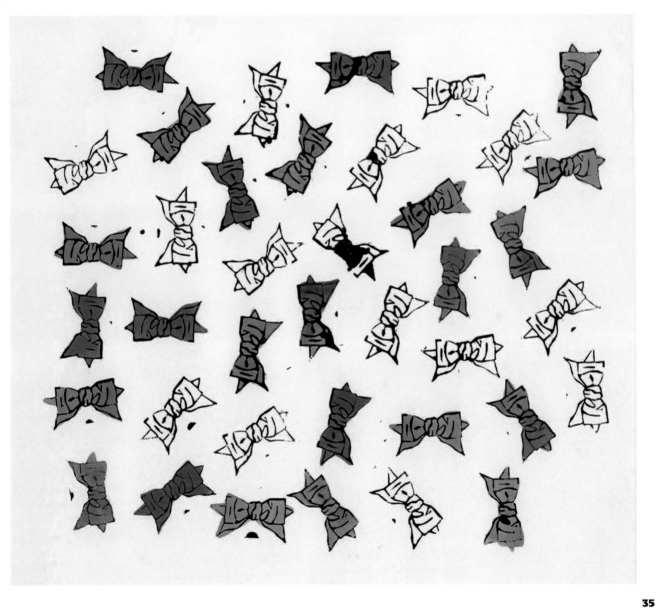

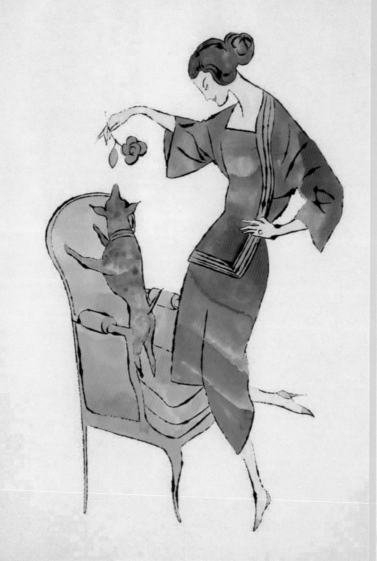
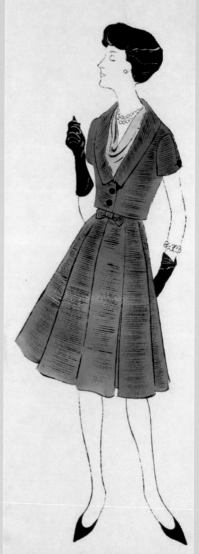

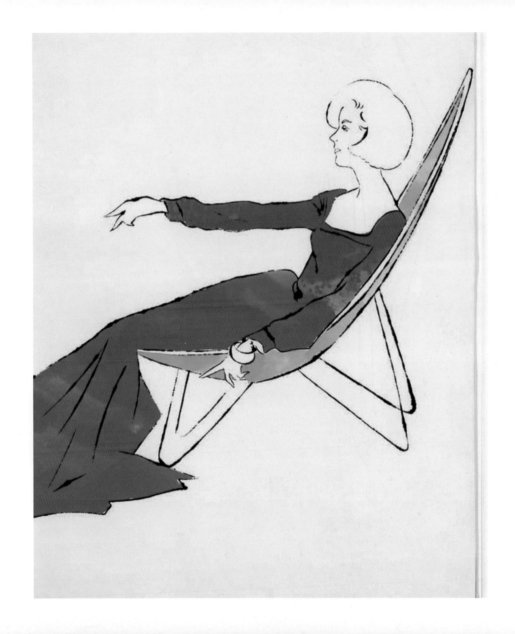

I've heard it said that my paintings are as much a part of the fashionable world as clothes and cars....

I don't think there's anything wrong with being fashionable or successful.

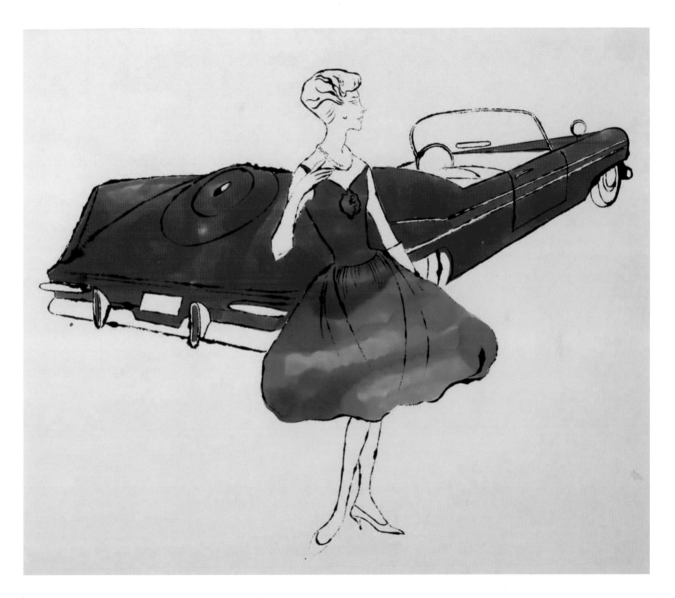

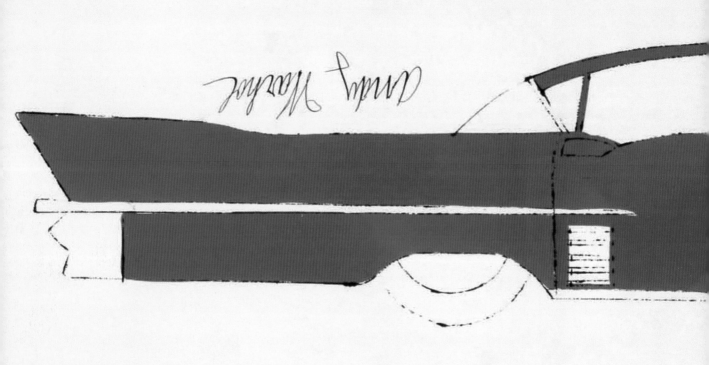

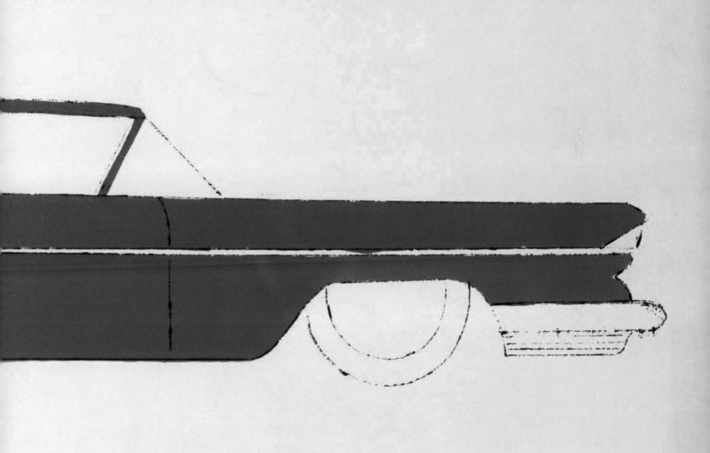

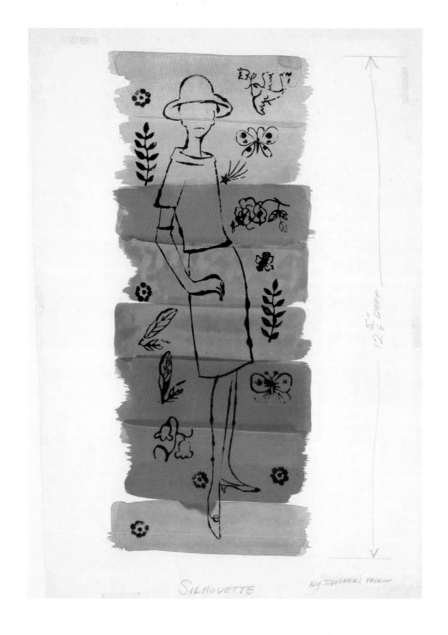

SILHOUETTE N.Y. J.WOMEN'S FASHION

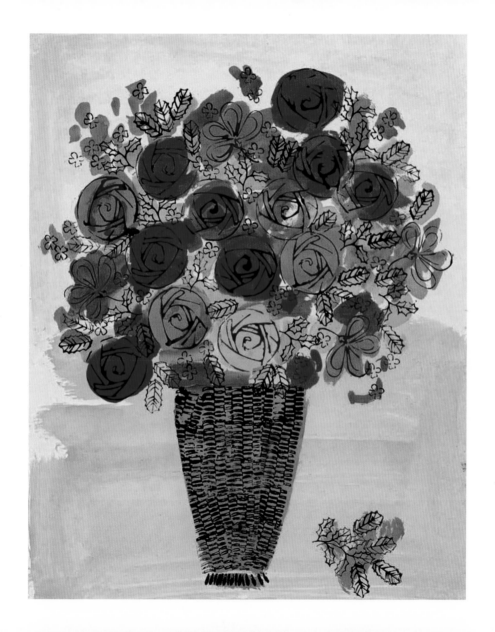

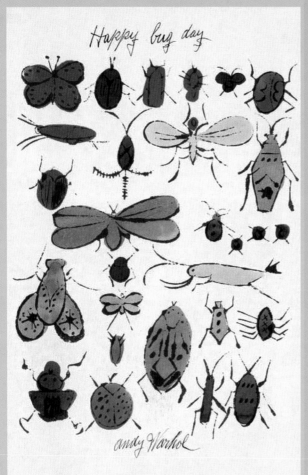

Happy bug day

andy Warhol

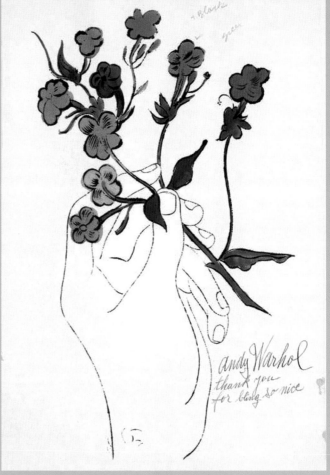

andy Warhol
thank you
for being so nice

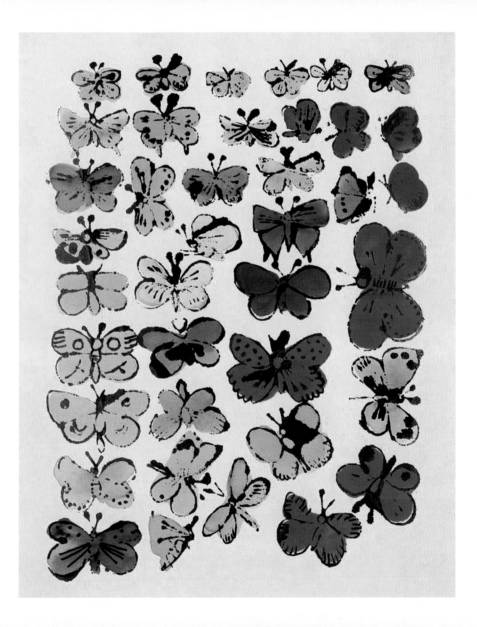

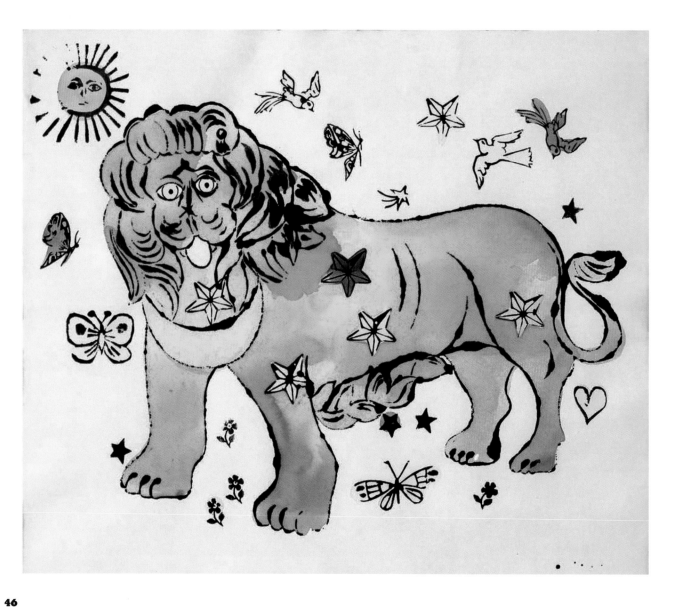

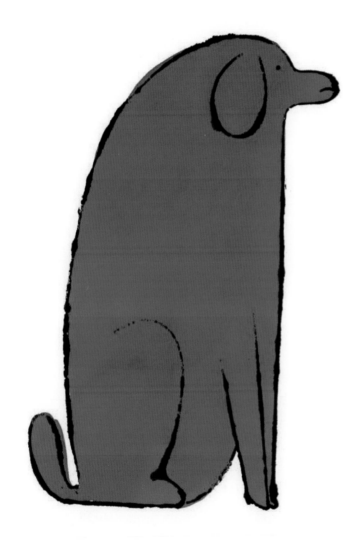

you are so little

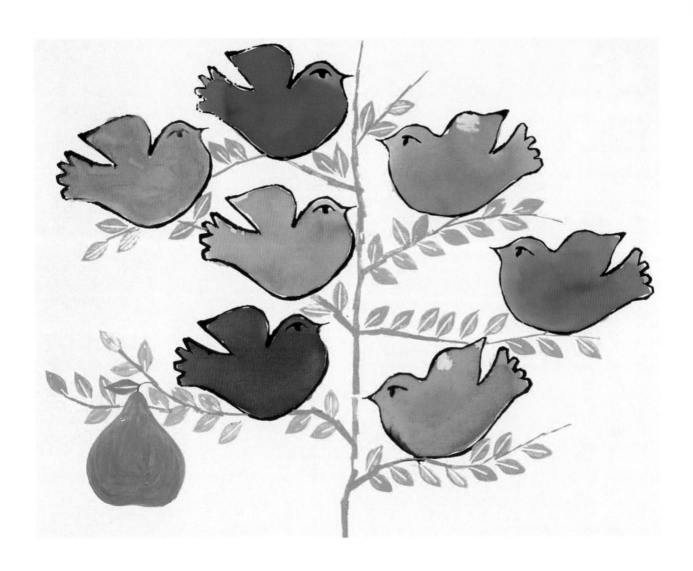

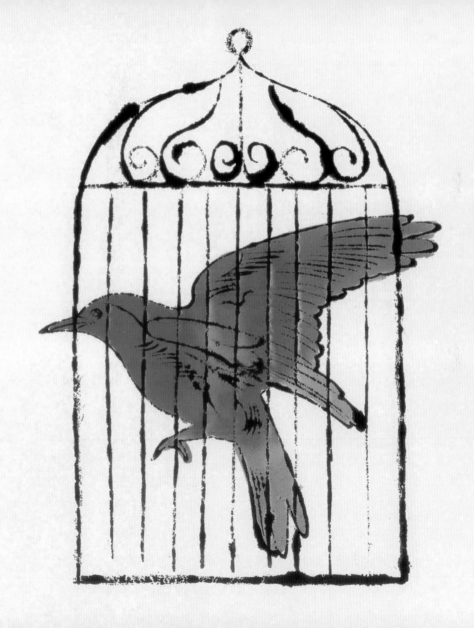

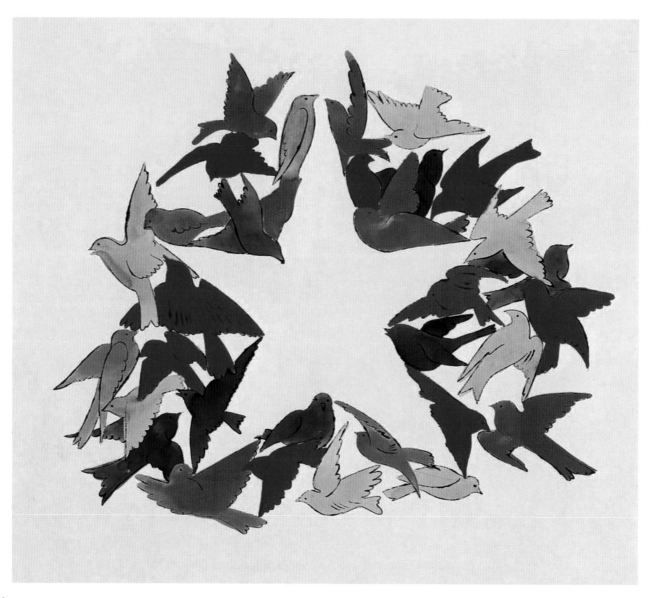

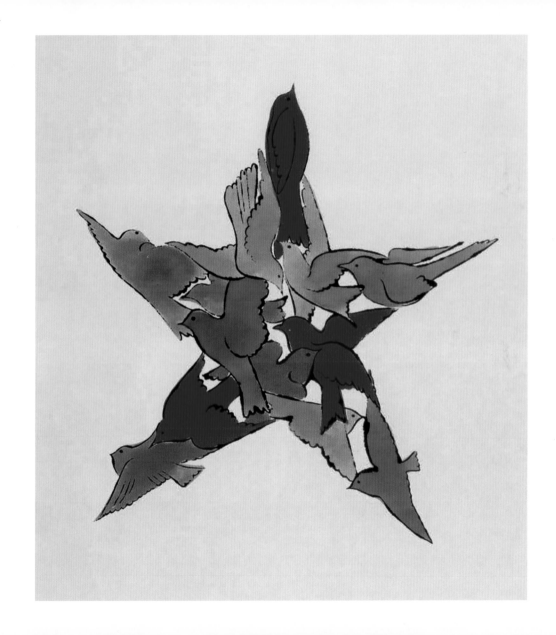

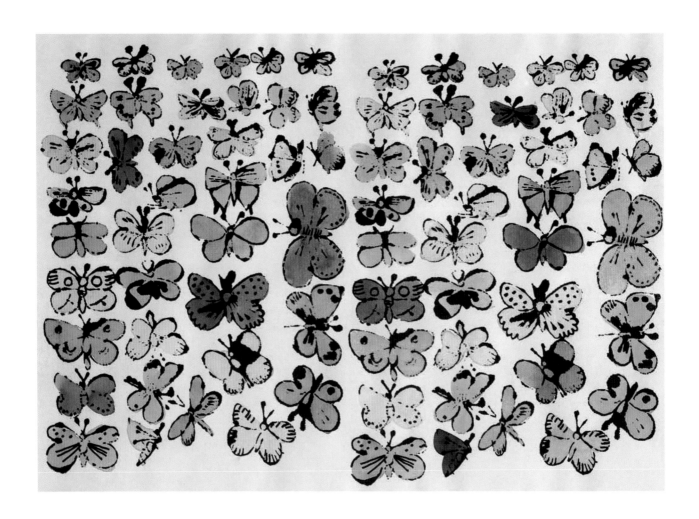

My favorite smell is the first smell of spring in New York.

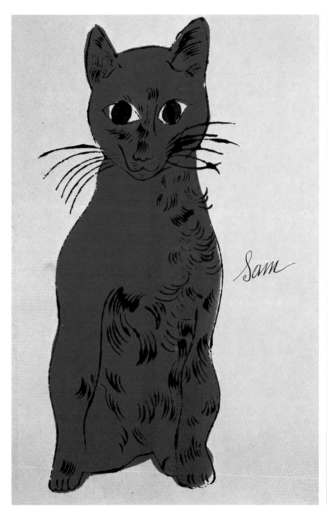

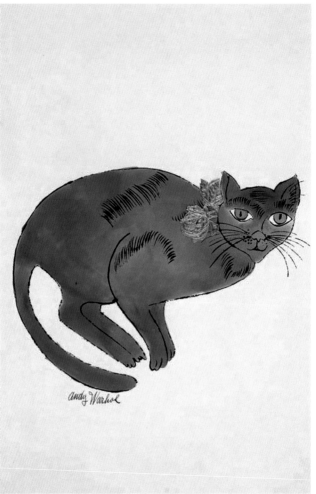

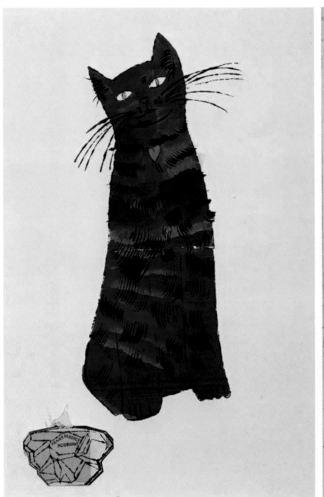

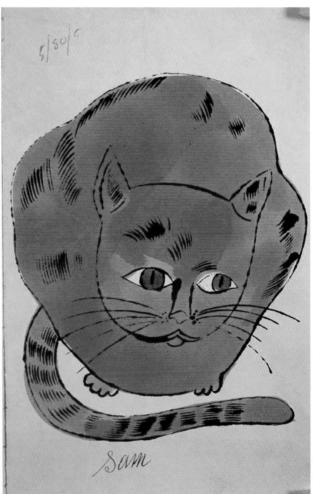

5/50/5

Sam

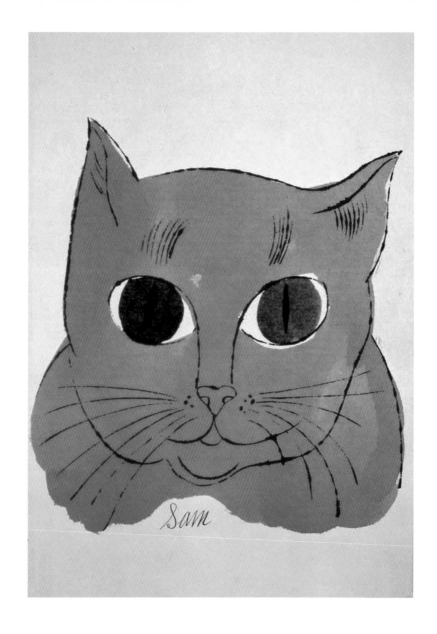

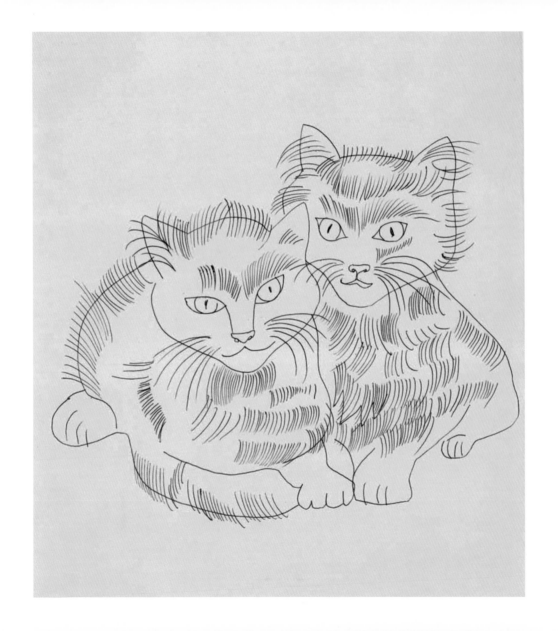

Purr Purr

So Happy

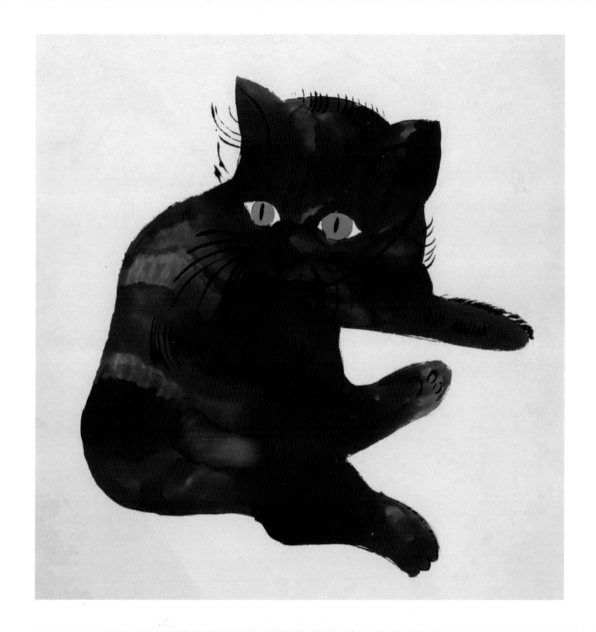

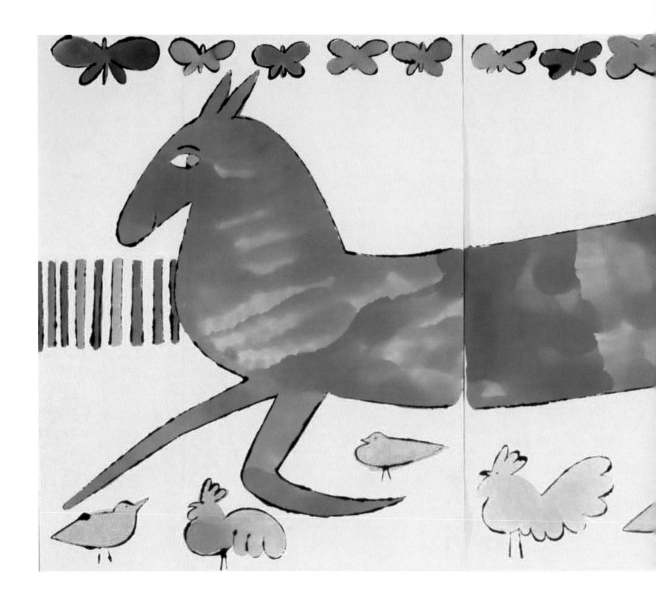

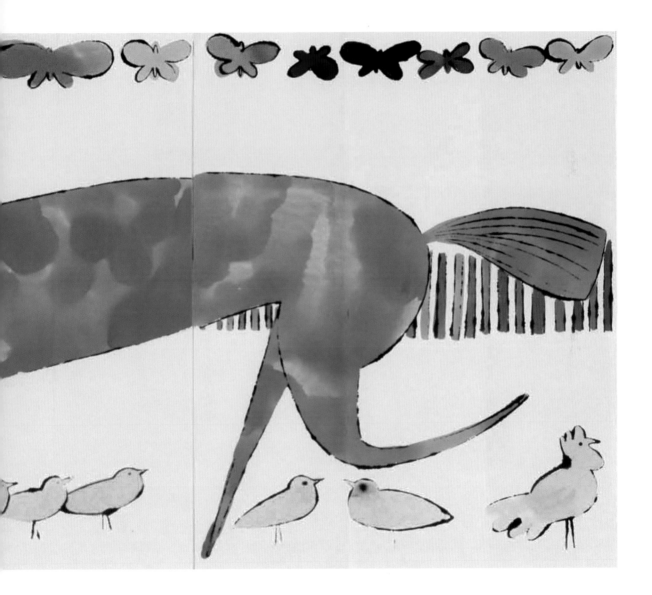

I never wanted to be a painter; I wanted to be a tap-dancer.

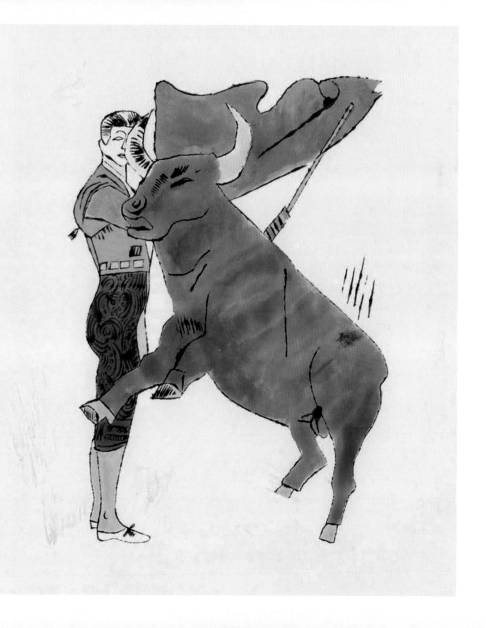

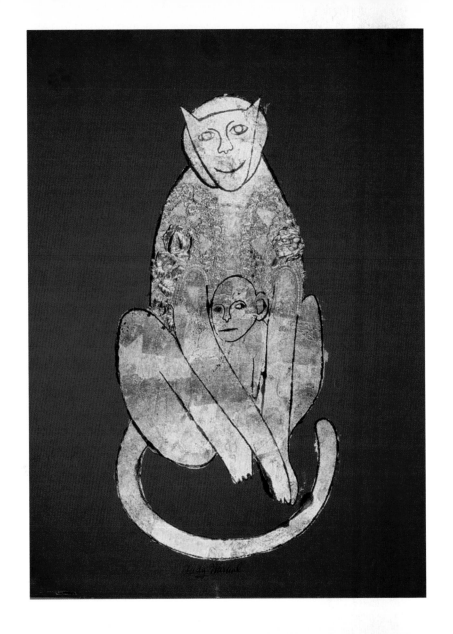

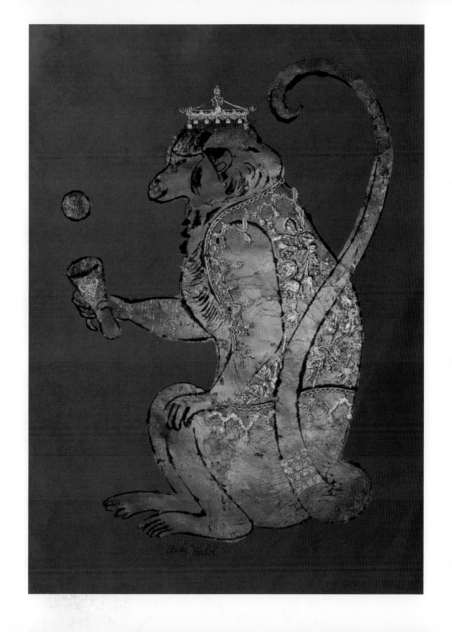

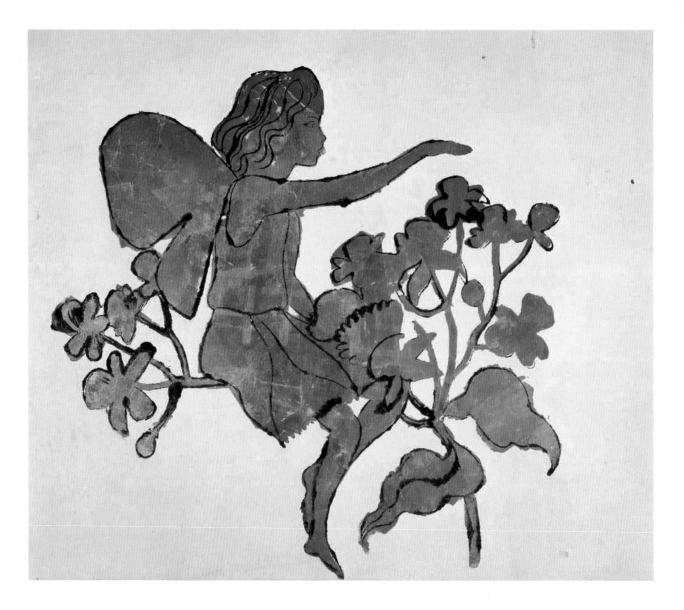

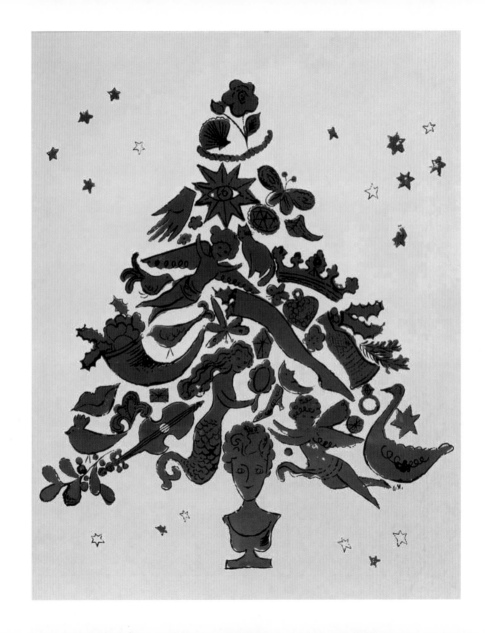

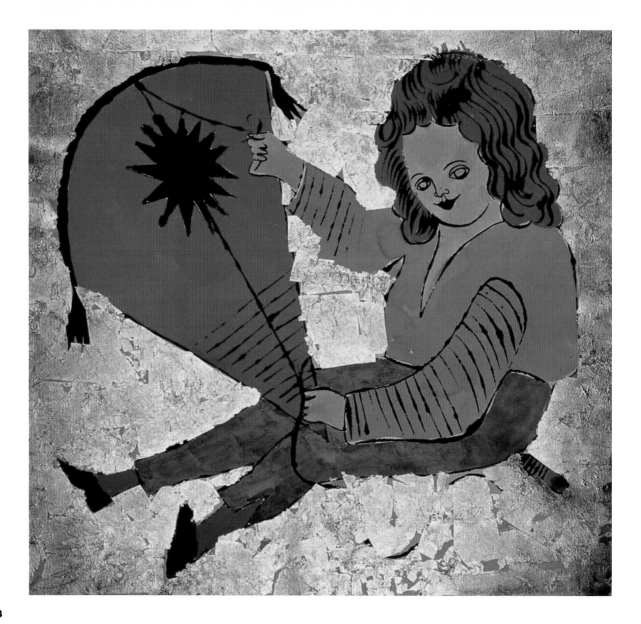

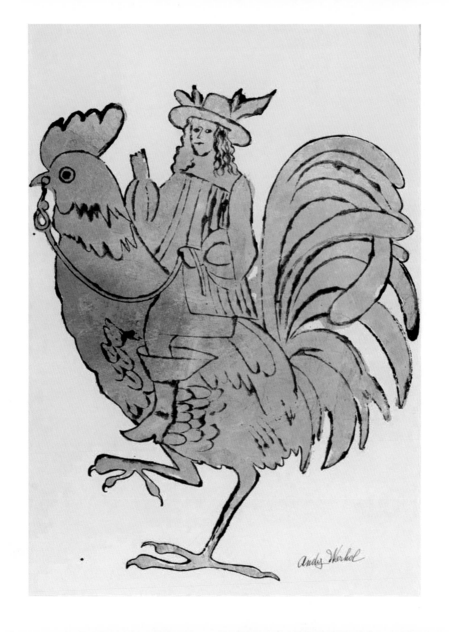

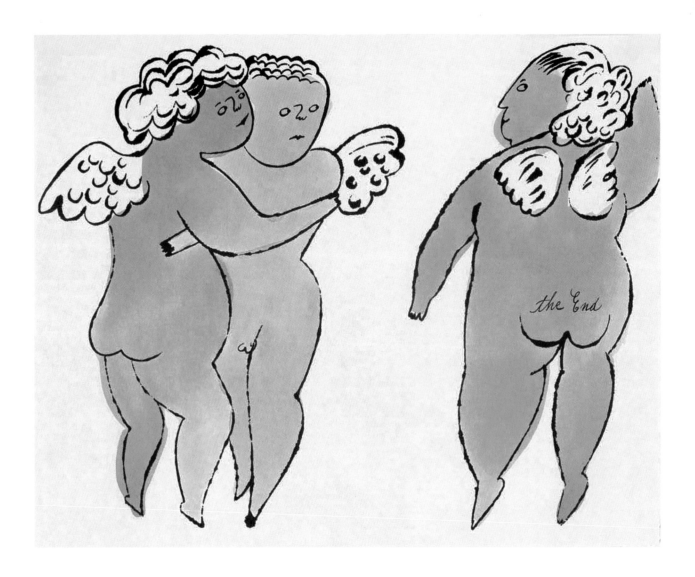

the End

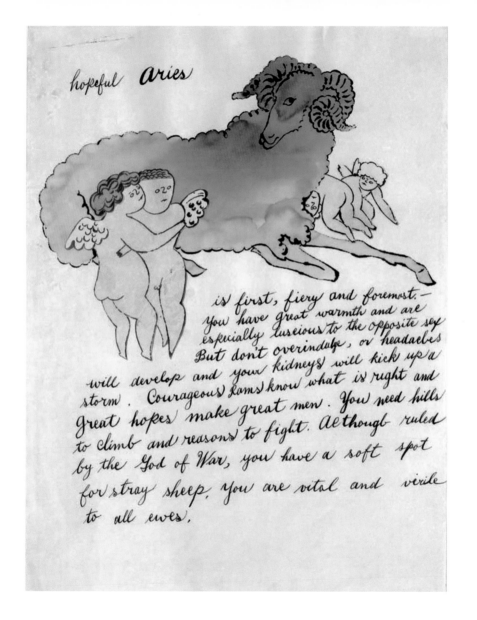

hopeful *Aries*

is first, fiery and foremost.— You have great warmth and are especially luscious to the opposite sex. But don't overindulge, or headaches will develop and your kidneys will kick up a storm. Courageous Rams know what is right and great hopes make great men. You need hills to climb and reasons to fight. Although ruled by the God of War, you have a soft spot for stray sheep, you are vital and virile to all ewes.

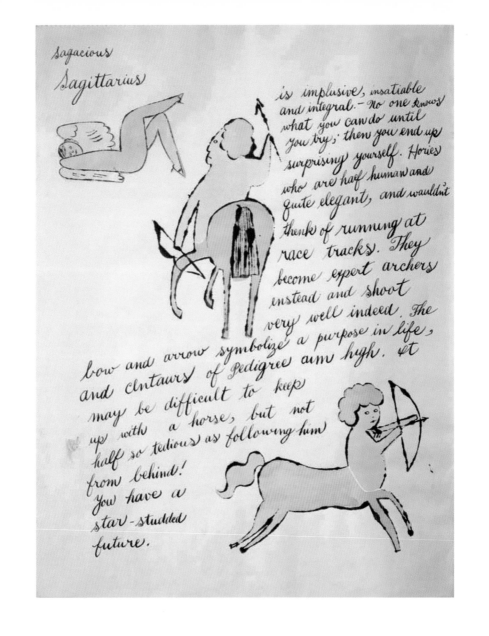

sagacious

Sagittarius

is impulsive, insatiable and integral. — No one knows what you can do until you try; then you end up surprising yourself. Horses who are half human and quite elegant, and wouldn't think of running at race tracks. They become expert archers instead and shoot very well indeed. The bow and arrow symbolize a purpose in life, and Centaurs of Pedigree aim high. It may be difficult to keep up with a horse, but not half so tedious as following him from behind! You have a star-studded future.

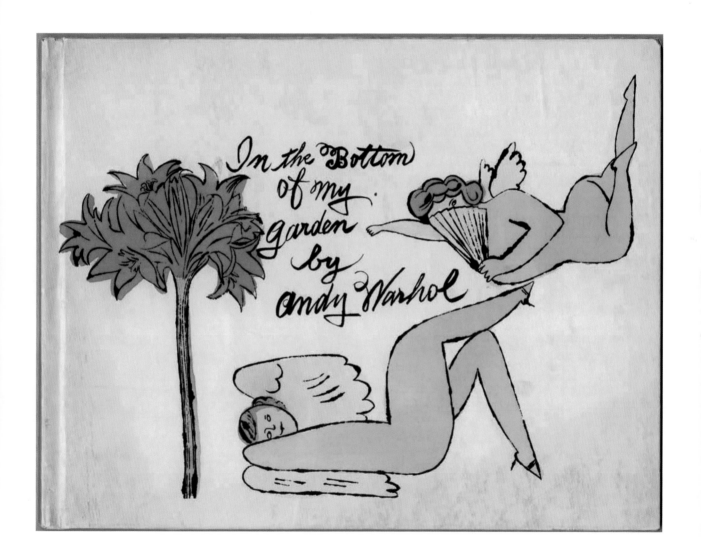

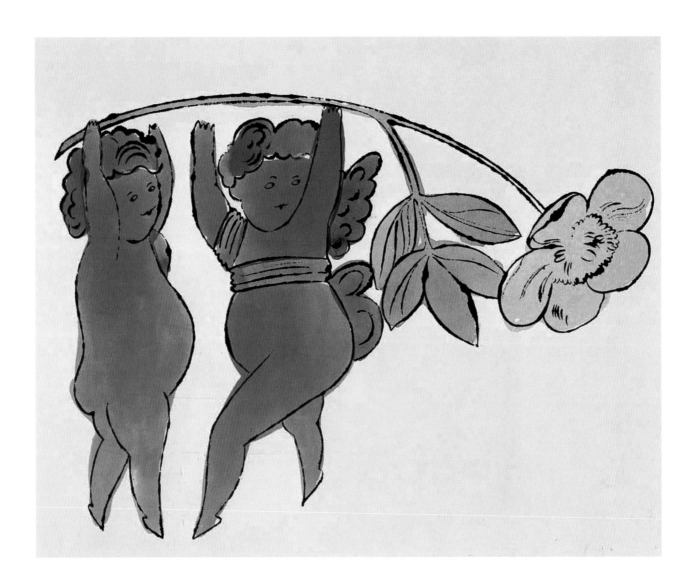

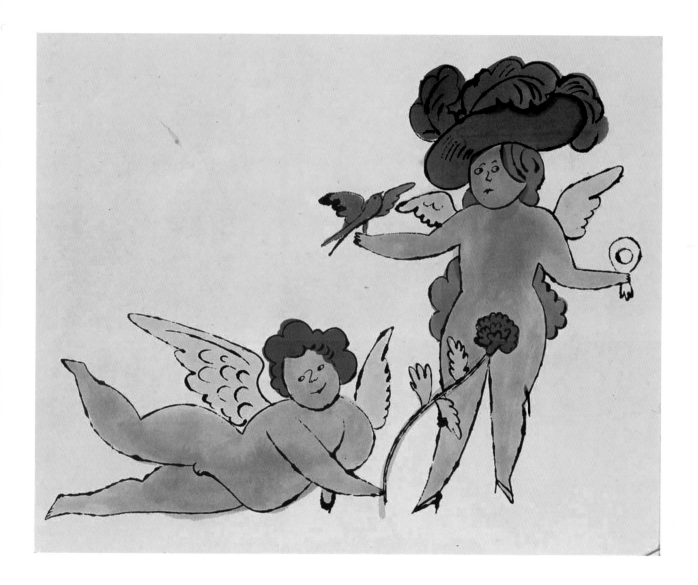

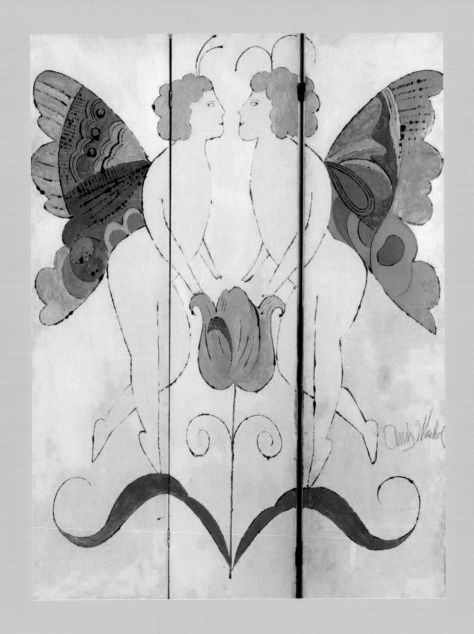

When you think about it, *department stores* *are kind of* *like museums.*

List of drawings

Page 55: *Untitled* (from the portfolio *Twenty-five Cats Named Sam and a Blue Cat Named Pussy*), ca. 1954.

Page 56: *Untitled* (from the portfolio *Twenty-five Cats Named Sam and a Blue Cat Named Pussy*), ca. 1954.

Page 57: *Two Seated Cats*, ca. 1954. Pen on manila paper, 43.2 x 35.6 cm.

Page 58: *So Happy*, 1950s. Ink, graphite, and Dr. Martin's Aniline Dye on paper, 24.8 x 31.8 cm.

Page 59: *Untitled* (from the portfolio *Twenty-five Cats Named Sam and a Blue Cat Named Pussy*), ca. 1954. Ink and Dr. Martin's Aniline Dye on Strathmore paper, 58.4 x 37.1 cm.

Pages 60–61: *Large Horse.* Ink and dye on paper, 96.6 x 42.9 cm.

Page 63: *Toreador*, ca. 1955. Ink and Dr. Martin's Aniline Dye on Strathmore paper, 73.7 x 58.4 cm.

Page 64: *Seated Monkey with Baby*, ca. 1957. Gold leaf and ink on colored art paper, 55.9 x 40.6 cm.

Page 65: *Monkey*, ca. 1957. Gold leaf, ink, and collage on paper, 55.9 x 40.6 cm.

Page 66: *Untitled* (winged child), ca. 1957. Gold leaf and ink on Strathmore paper, 45.7 x 58.4 cm.

Page 67: *Untitled.*

Page 68: *Untitled* (child with kite), ca. 1957. Gold leaf, ink, and stamped gold ink on Strathmore paper, 58.1 x 41.3 cm.

Page 69: *Untitled* (man astride a rooster), ca. 1957. Gold leaf and ink on Strathmore paper, 50.8 x 36.2 cm.

Page 70: *Untitled* (from *In the Bottom of My Garden*), ca. 1954. Offset lithography, watercolor, and pen on paper, 20.4 x 28.6 cm.

Page 71: *Hopeful Aries*, 1959. Ink, collage on paper, and dye, 60.3 x 45.7 cm. Jose Mugrabi Collection, New York.

Page 72: *Sagacious Sagittarius*, 1959. Ink, collage on paper, and dye, 60.3 x 45.7 cm. Jose Mugrabi Collection, New York.

Page 73: *Untitled* (cover of *In the Bottom of My Garden*), ca. 1956. Offset lithography and Dr. Martin's Aniline Dye on buckram, 21.6 x 27.9 cm.

Page 74: *Angels with a Flower* (from *In the Bottom of My Garden*), 1955. Offset lithography, watercolor, 21.6 x 27.9 cm.

Page 75: *Untitled* (from *In the Bottom of My Garden*), ca. 1954. Offset lithography, watercolor, and pen on paper, 21.6 x 27.9 cm.

Page 76: *Screen*, 1950s. Tempera and ink on cardboard and wooden screen, 163.8 x 127 cm.

Back cover: *So Happy*, 1950s. Ink, graphite, and Dr. Martin's Aniline Dye on paper, 24.8 x 31.8 cm.

© 2007 Andy Warhol Foundation for the Visual Arts / ADAGP, Paris for all Andy Warhol works.

List of citations

Page 21: Barry Blinderman, "Modern Myths: Andy Warhol," in *Arts*, October 1981, *I'll Be Your Mirror: The Selected Andy Warhol Interviews, 1926–1987*, ed. Kenneth Goldsmith, 299 (New York: Carroll & Graf Publications, 2004).

Page 31: Gretchen Berg, "Andy Warhol: My True Story," in *The East Village Other*, October 1981, *I'll Be Your Mirror: The Selected Andy Warhol Interviews, 1926–1987*, ed. Kenneth Goldsmith, 95 (New York: Carroll & Graf Publications, 2004).

Page 38: Gretchen Berg, "Andy Warhol: My True Story," in *The East Village Other*, October 1981, *I'll Be Your Mirror: The Selected Andy Warhol Interviews, 1926–1987*, ed. Kenneth Goldsmith, 88 (New York: Carroll & Graf Publications, 2004).

Page 53: Phaidon, *Andy Warhol "Giant" Size*, 355 (London: Phaidon, 2009).

Page 62: Gretchen Berg, "Andy Warhol: My True Story," in *The East Village Other*, October 1981, *I'll Be Your Mirror: The Selected Andy Warhol Interviews, 1926–1987*, ed. Kenneth Goldsmith, 89 (New York: Carroll & Graf Publications, 2004).

Page 77: Andy Warhol, *America*, 22 (New York: Penguin Group, 2011).

Photographic credits